Mindful Calligraphy

Callimantra

BATSFORD

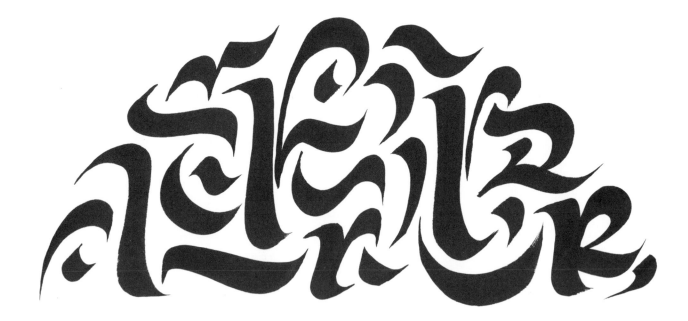

Table of Contents

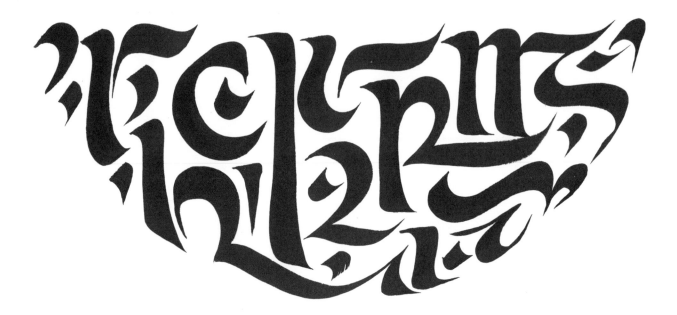

CHAPTER 5

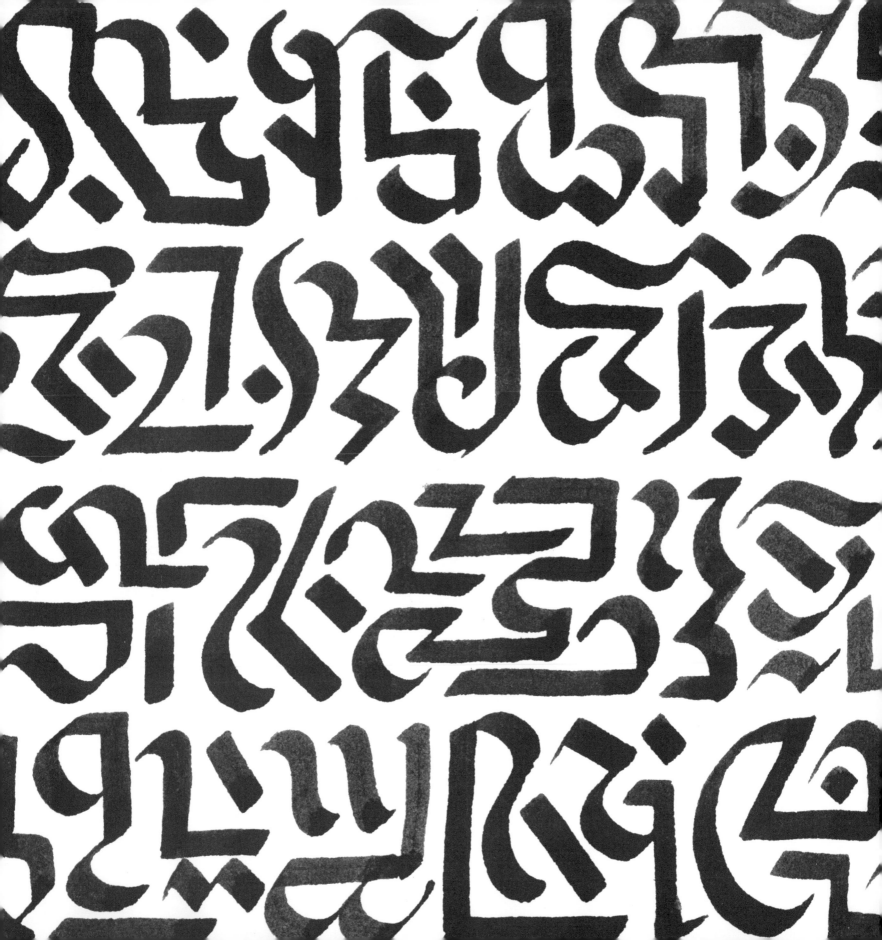

Introduction
Calligraphy and Mindfulness

More than ever, we need to reconnect with ourselves. Life today is so hectic, it's easy to lose track of who we really are.

Meditation techniques can tune out the stresses of life in the modern world and help us get back in touch with our inner selves. But it isn't always that easy. Sometimes it's useful to have a tool that helps you reach a meditative state.

In certain cultures, calligraphy has long been recognized as a method for spiritual self-expression.

Mindful Calligraphy lays out an innovative method that makes calligraphy a tool for meditation in a contemporary context.

In *Mindful Calligraphy* you will find out how you can apply the practice of calligraphy to the Western alphabet, focusing your mind and tuning out daily pressures.

The book is a simple tool that will help you to fuse the art of beautiful writing with meditation and reflection. In these pages, we make use of the power of words and phrases to focus your mind, and calligraphy to anchor you in reality.

By learning and perfecting the art of writing, you will also learn to find peace and insight.

The Gate

There is a gate in your mind.
Close your eyes and try to visualise it.

The gate protects the garden of your
calligraphic meditation and it is made
of ink.

Every time you step through it, you are
safe from the pressures of the outside
world. But don't forget to close it
behind you when you leave.

There is a technique to opening the gate.

You must become familiar with it,
practice it, memorise it, until it
becomes second nature.

There are four stages to opening the
gate and getting ready to begin.

Read on...

Open the gate
when you start.
Close the gate
when you leave.

Sit

Sit down. Make sure there is enough light — natural light, ideally. Do you have everything you need to hand? Ink? Water?

Sit comfortably with your back straight but not rigid. Don't twist your body or hunch your shoulders — this will lead to tension and headaches.

Chest expands, back relaxes, and shoulders settle into their natural posture.

Before you pick up your pen, let your mind run the length of your body. Does everything feel right? Can you detect any discomfort or tension? Fix it. Help your body settle.

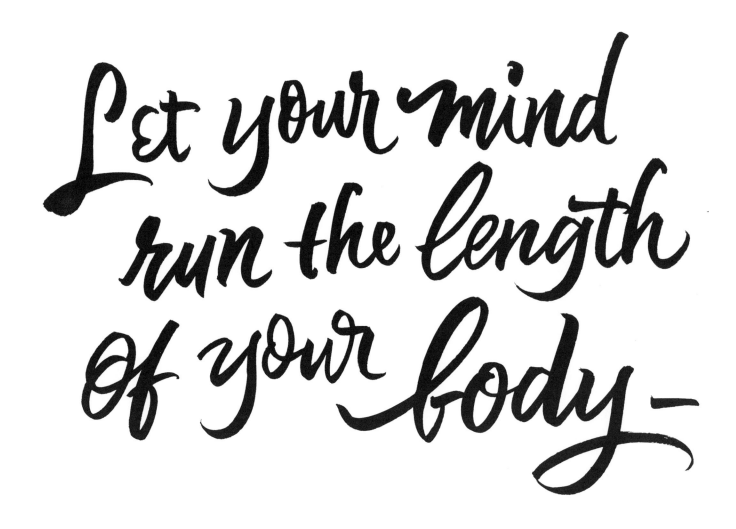

Let your mind run the length of your body—

Close your eyes

These exercises are a systematic training program for the mind.

You will learn how to concentrate and use the mind positively.

The first step: shut out the world. Close your eyes and look inwards.

Concentration and attention must be developed, cultivated, sustained.

This will help you get to the root of anxiety.

Being in the present is a way to unite mind and body. Looking inward, your mind will focus, and your mental condition will evolve.

Train your body progressively, unifying mental and physical energies.

being in the
present is a way
to unify mind
and body

Focus

The pen is the point where mind meets body.

The pen itself must be calm and focused before you touch it to paper. Hold it gently and focus through it.

Don't grip the pen too tight, nor hold it too slackly.

True relaxation is not the same as simply letting go.

Your elbow shouldn't stick out, as this will unbalance your arm and lead to tension in the muscles. But your elbow shouldn't hang down, either, slowing down your hand.

Feel the pen in your hand.

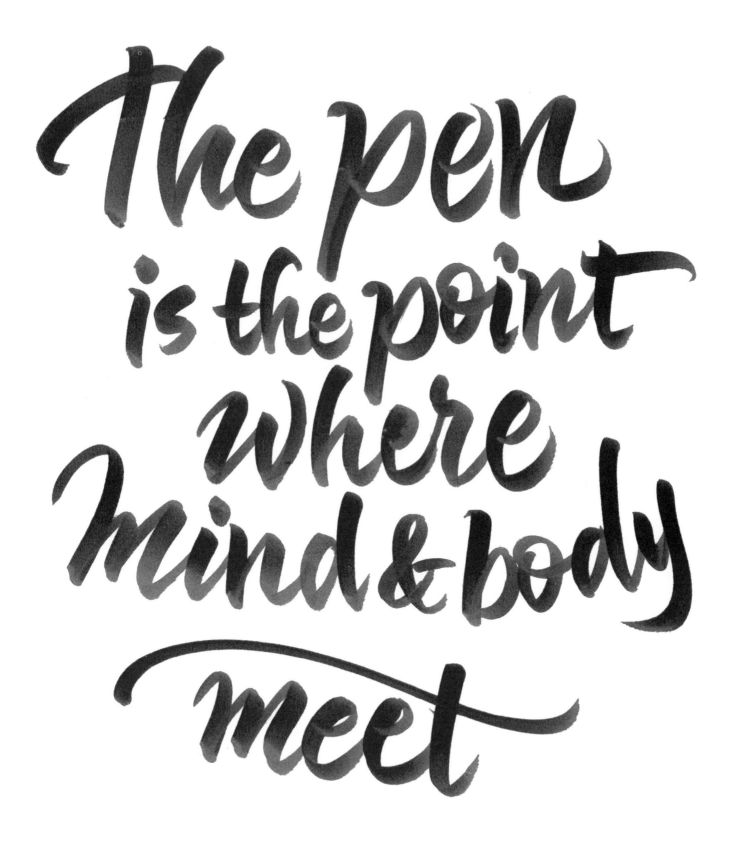

The pen is the point where mind & body meet

Breathe

Forget what you know.
We need to relearn how to breathe.

Sit. Disconnect.
Breathe in through your nose.

Follow your breath as it moves through
your nose and down to your lungs.

Follow your breath up through your
throat and out of your nose.

Repeat.

Repeat again.

Repeat again.

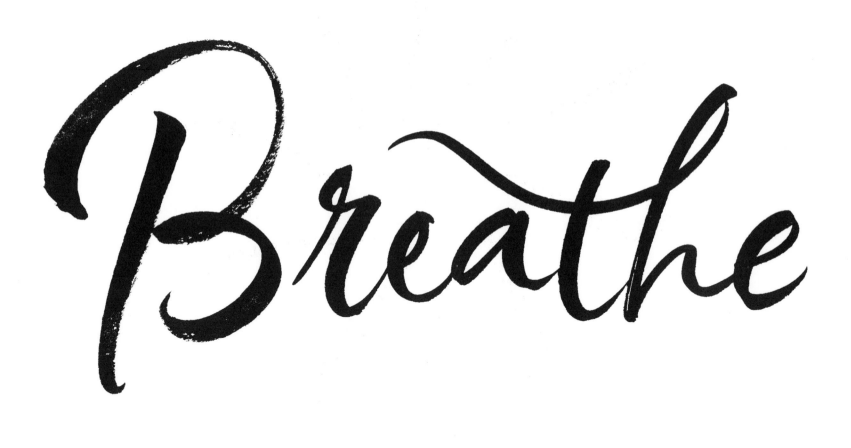

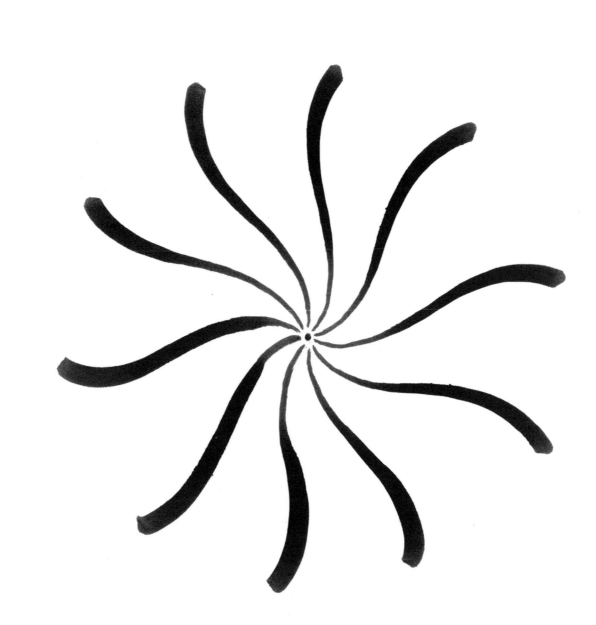

Sit,
Close your eyes
Focus, breathe.
Now open the gate.

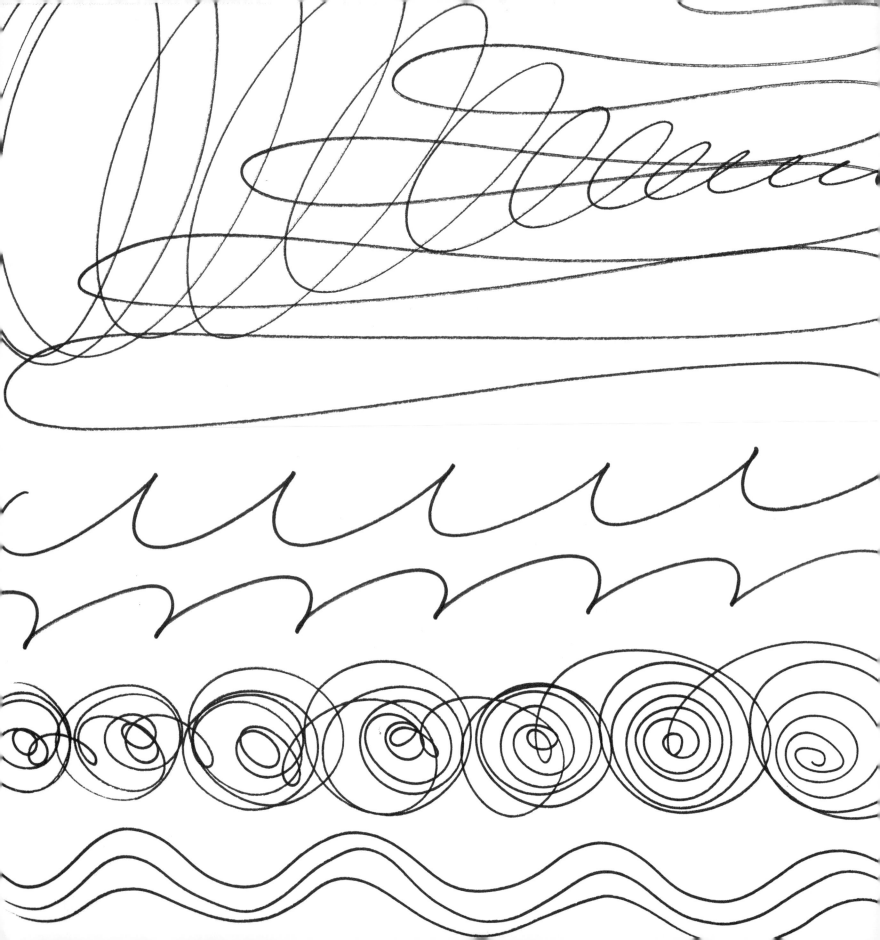

The Nine Triumphs - Pen to Paper

..

In the following pages you will find the *Triumphs*.

These are symbolic shapes with a dual function:
warming up your hand, and warming up your spirit.

You will return to these pages over and over.

In fact, it is recommended that you start each
session with some of these exercises.

A gentle flood of ink.

We see a field of grass.

The points where the grass emerges from the earth.

A wind comes and bends the grass.

First that way, now this.

Range upon range of mountains, stretching to the horizon.

A flock of seagulls, carried on the wind.

Fishes swim to the surface to see what's what.

They stare blankly up at the sky.

Fishes swim back down to the depths.

Content that is where they belong.

The water is ruffled by the wind.

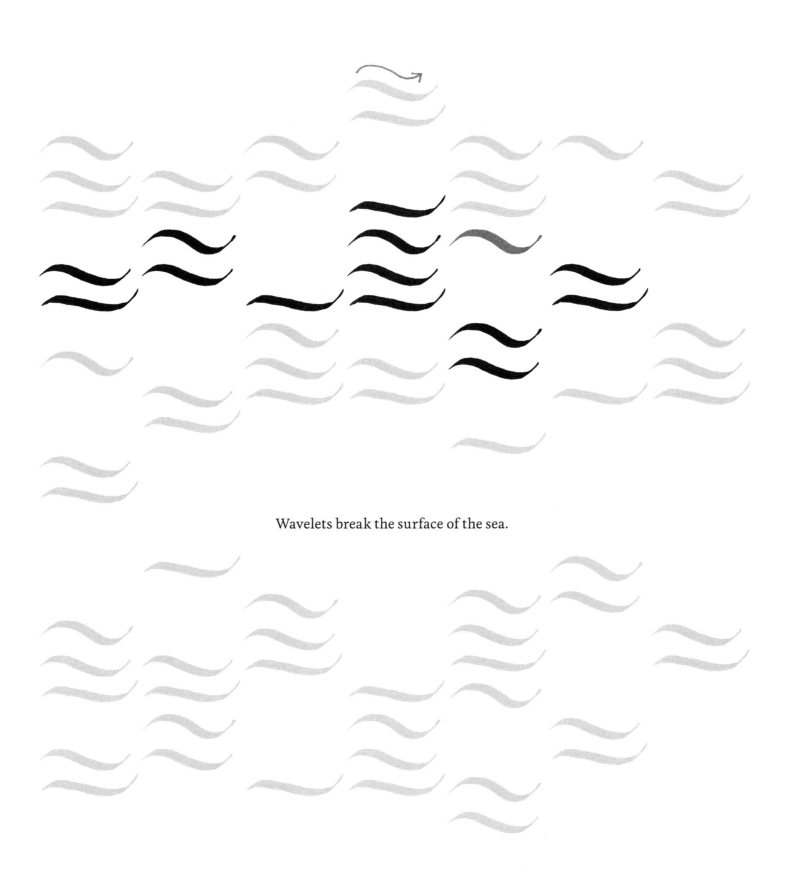

Wavelets break the surface of the sea.

A greater force tugs at the sea.

Great currents roil through the ocean.

The moon waxes.

The moon wanes.

The moon...

O

...is whole.

Facing Complexity - Multiple Strokes

The strokes are flowing out of you. The distance between mind and pen is growing smaller.

Now you are going to start to tame those wild strokes. Give them structure. Build with them.

By combining strokes together like building blocks you take a step closer to full, unmediated expression.

LLLLLLLLLLLLLLLLLLLLLL
LLLLLLLLLLLLLLLLLLLLLL
LLLLLLLLLLLLLLLLLLLLLL

ꞀꞀꞀꞀꞀꞀꞀꞀꞀꞀꞀꞀꞀꞀꞀꞀꞀꞀꞀꞀꞀꞀ

ꞀꞀꞀꞀꞀꞀꞀꞀꞀꞀꞀꞀꞀꞀꞀꞀꞀꞀꞀꞀꞀ

ꞀꞀꞀꞀꞀꞀꞀꞀꞀꞀꞀꞀꞀꞀꞀꞀꞀꞀꞀꞀꞀ

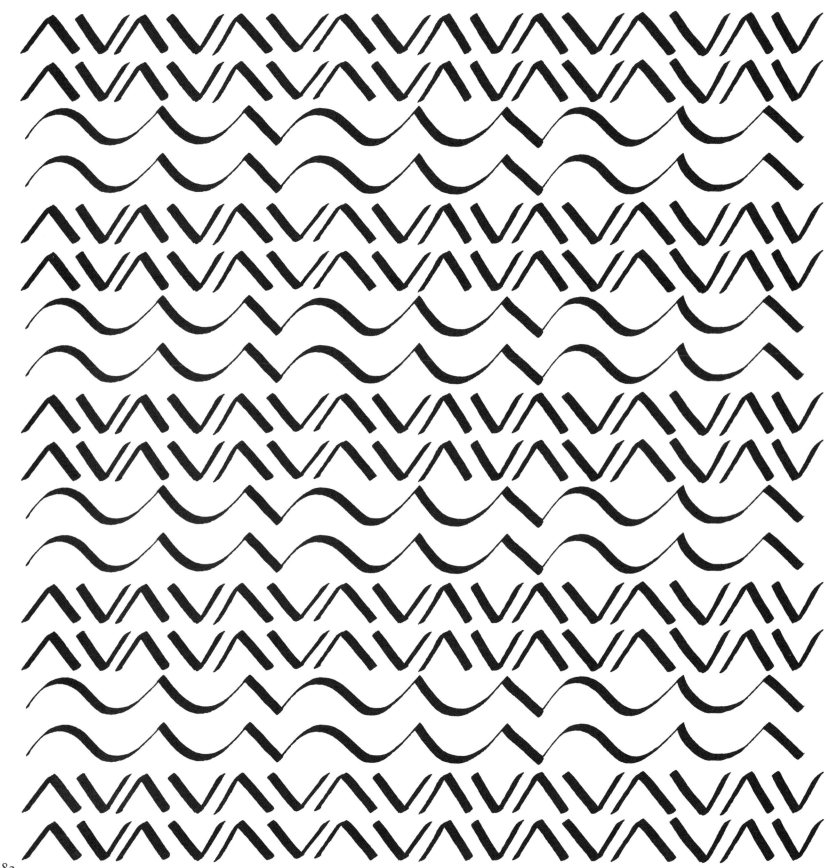

C C C C C C C C C C C C C

C C C C C C C C C C C C C

C C C C C C C C C C C C C

ててててててててててて

n n n n u n u m

n u u u u u n

n u n m m u n

n u m m m u n

n m u m u m u m n

n u m m m u n

n u m m n u n

n u u u u u u n

u u n u m n n n n

113

unumunumunumunum
unumunumunumunum
unumunumunumunum
unumunumunumunum
unumunumunumunum
unumunumunumunum
unumunumunumunum
unumunumunumunum
unumunumunumunum

unumunumumunumunum
unumumunumunumunum
unumumunumunumunum
unumunumunumunumunum
unumumunumunumunum
unumunumunumunumum
unumumunumunumum
unumunumumunumunum
unumunumumunumunum

m
mi
min
mini
minim
minimu
minimum
inimum
nimum
imum
mum
um
m

m
mi
min
mini
minim
minimu
minimum
minimum
inimumum
imumum
mumum
umum
um
m

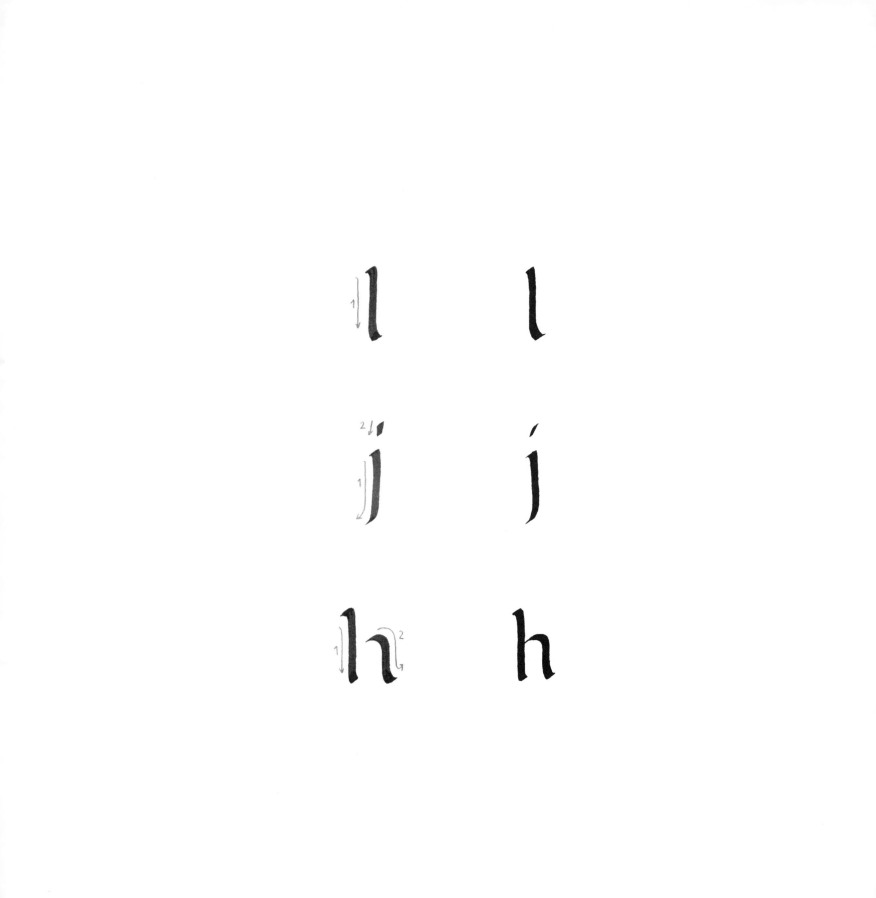

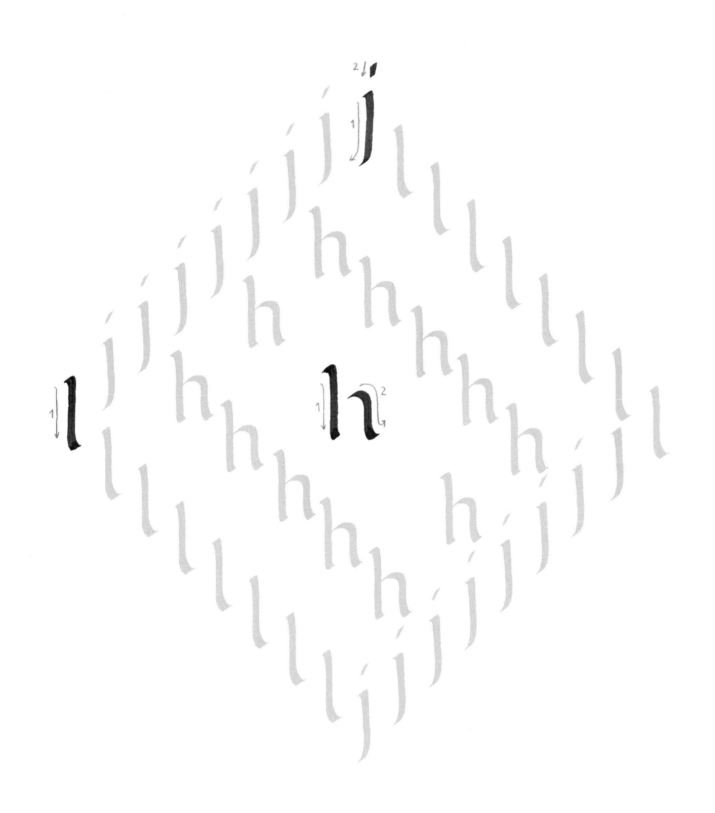

hill hill hill hill
hill hill hill hill
hill hill
hill
hi
hill
hill hill
hill hill hill hill
hill hill hill hill

hill hill hill hill
hill hill hill hill
hill hill
hill
hi
hill
hill hill
hill hill hill hill
hill hill hill hill

ohm

ohm ohm

ohm o
o o o
ohm

ohm o o o o ohm

ohm o o o o
o o o o ohm

o o o o
ohm o o o ohm

o

ohm ohm

ohm

ohm

ohm ohm

ohm o ohm

o o o

ohm o o o o ohm

O o o O O

ohm O O O O ohm

O O O

ohm O O O ohm

O

ohm ohm

ohm

b

p

d

q

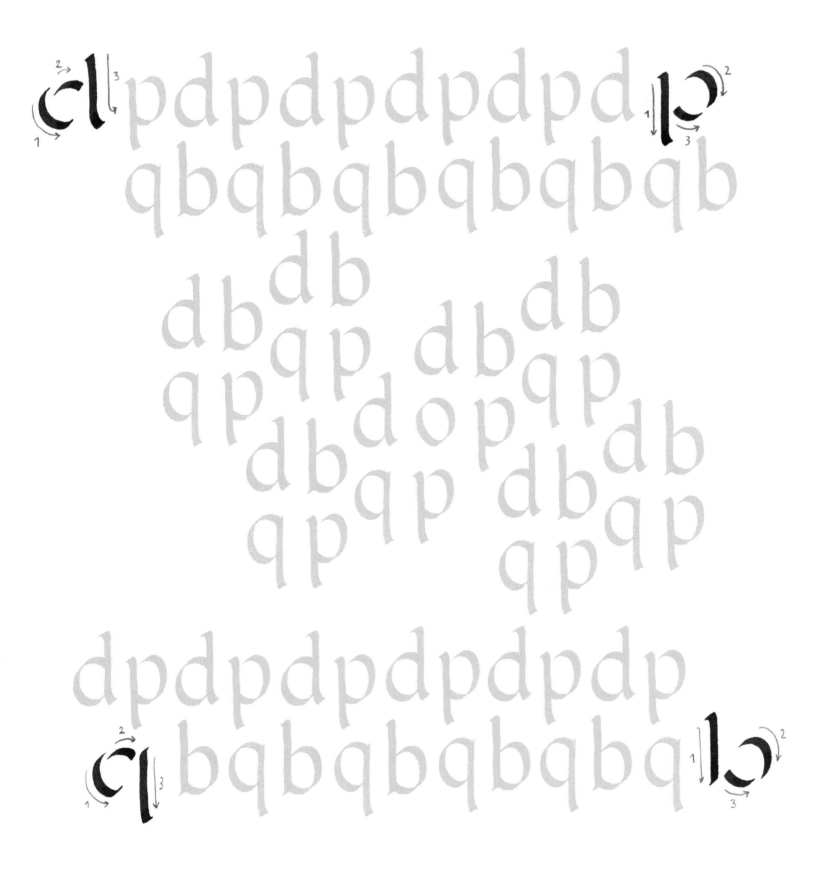

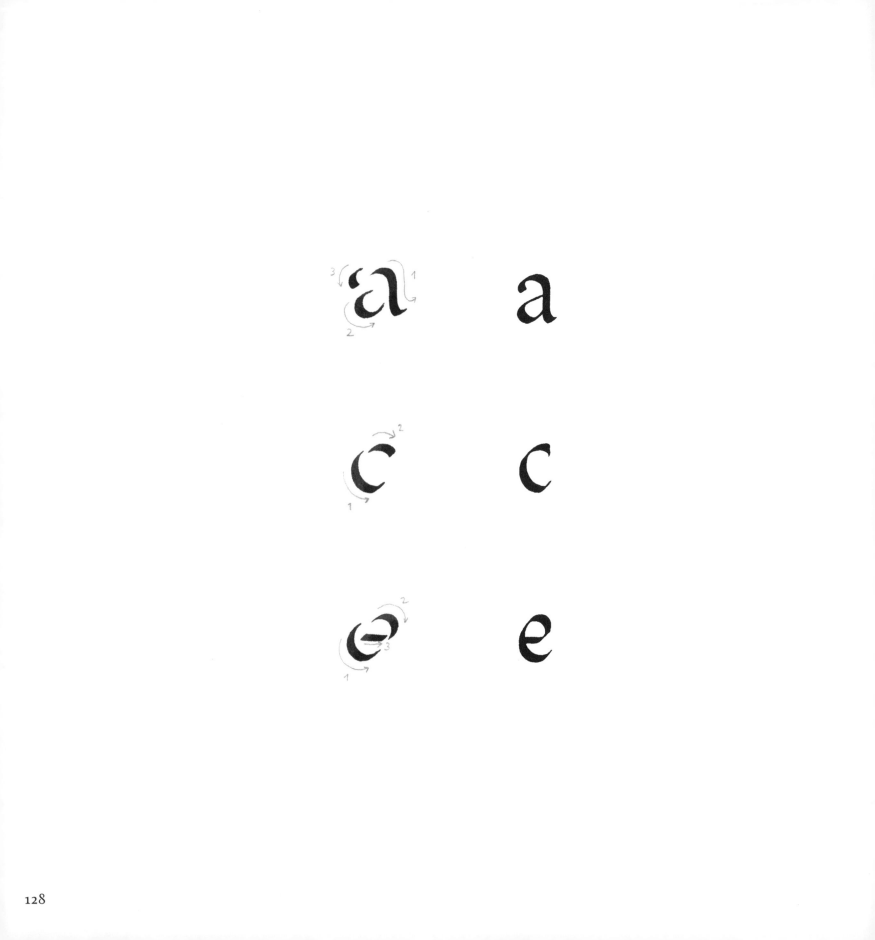

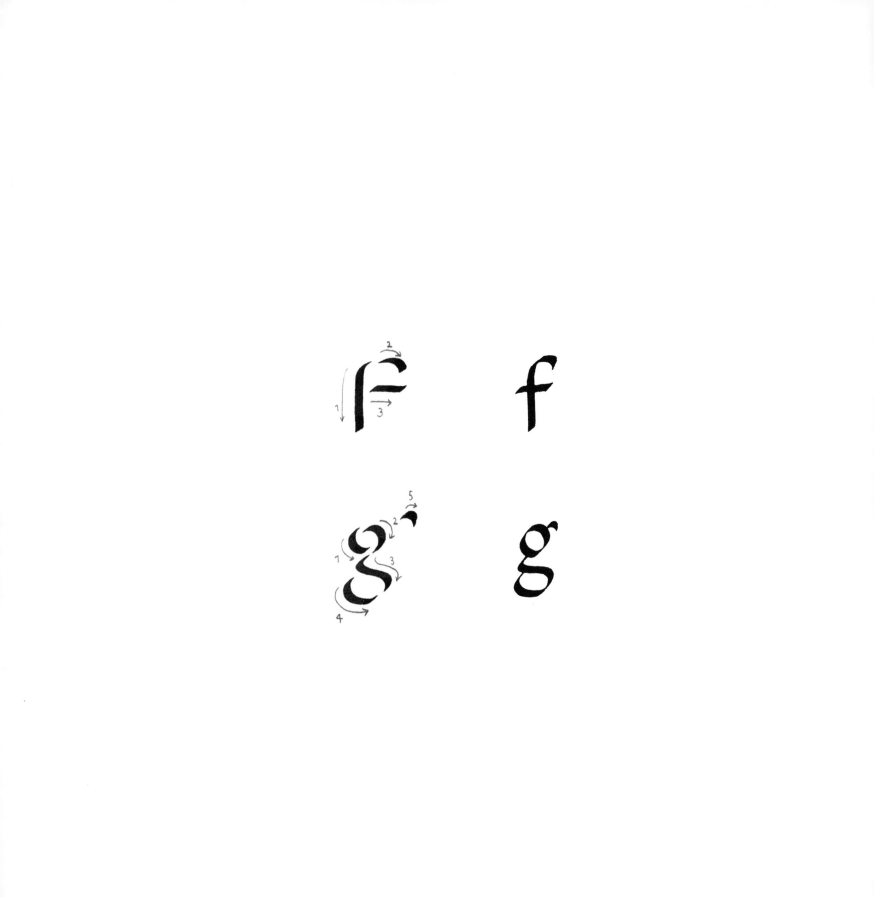

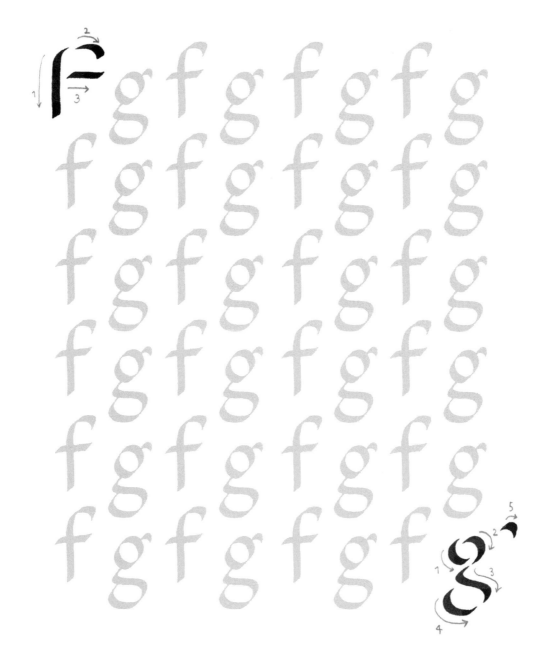

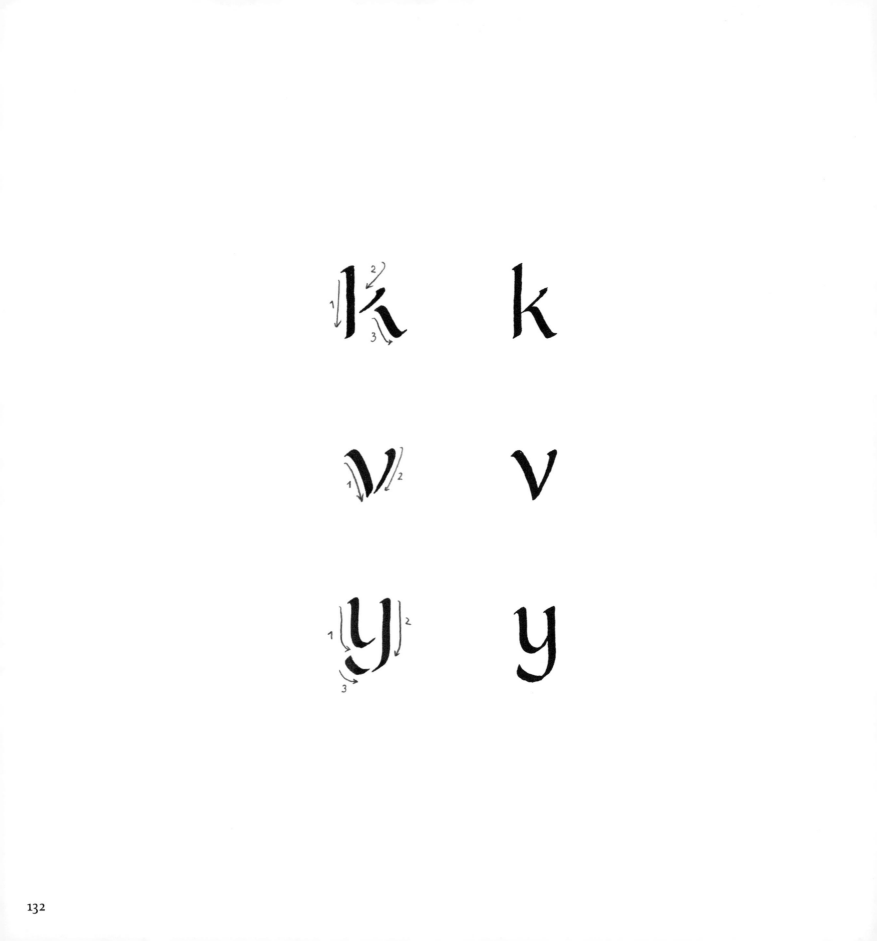

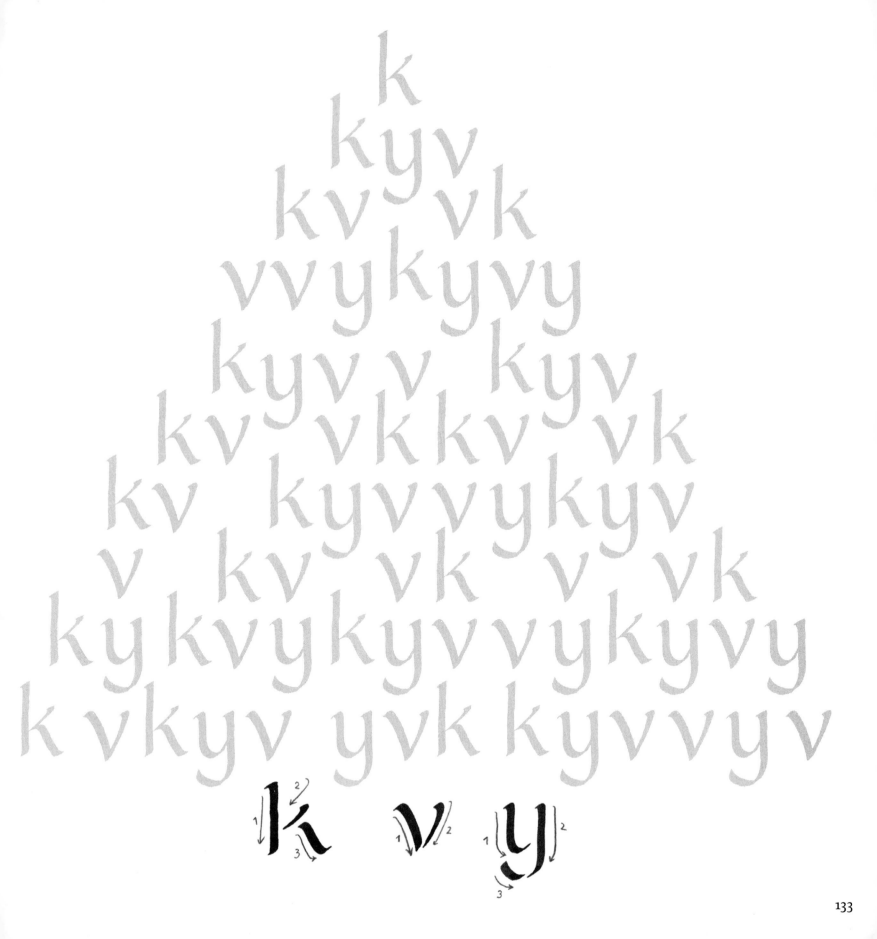

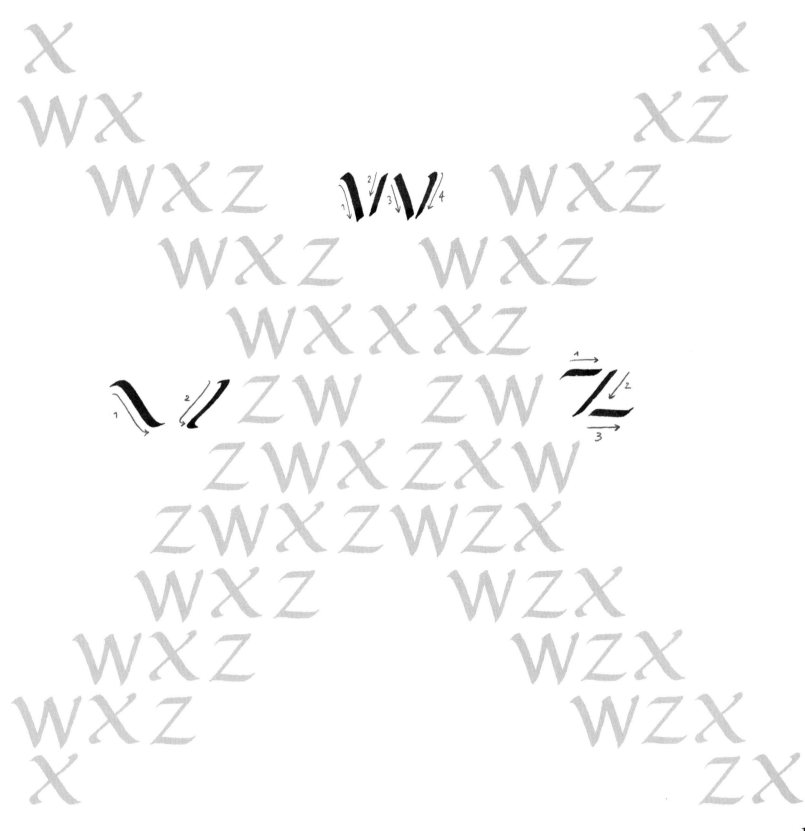

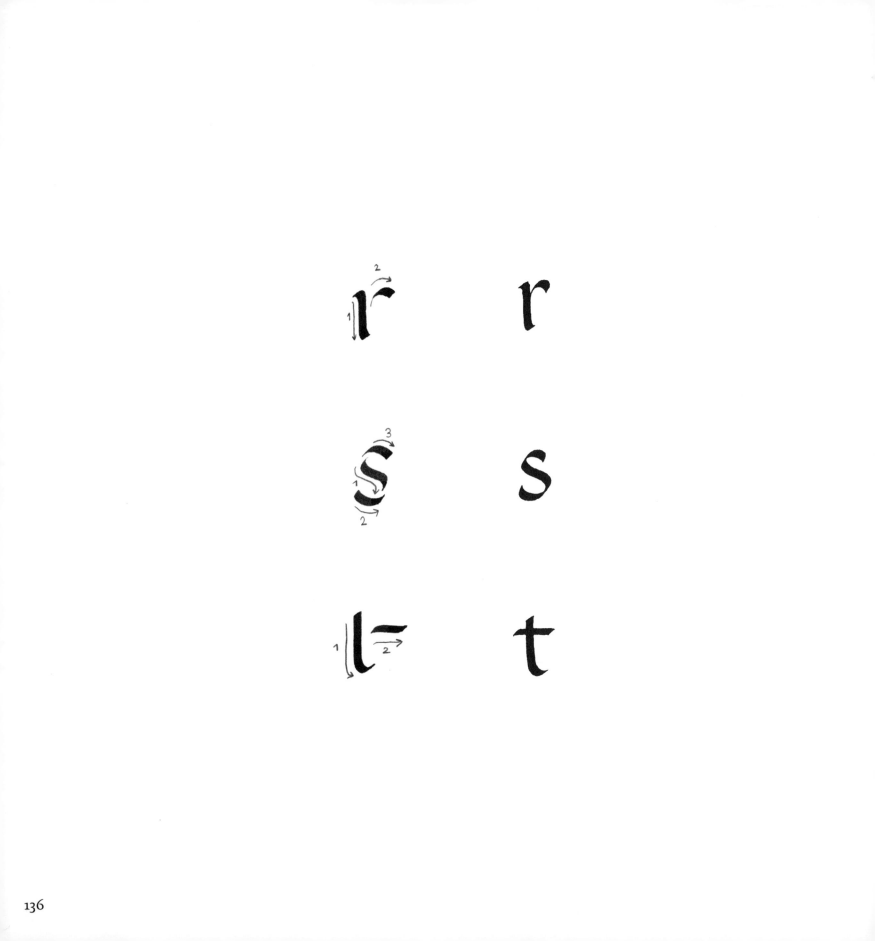

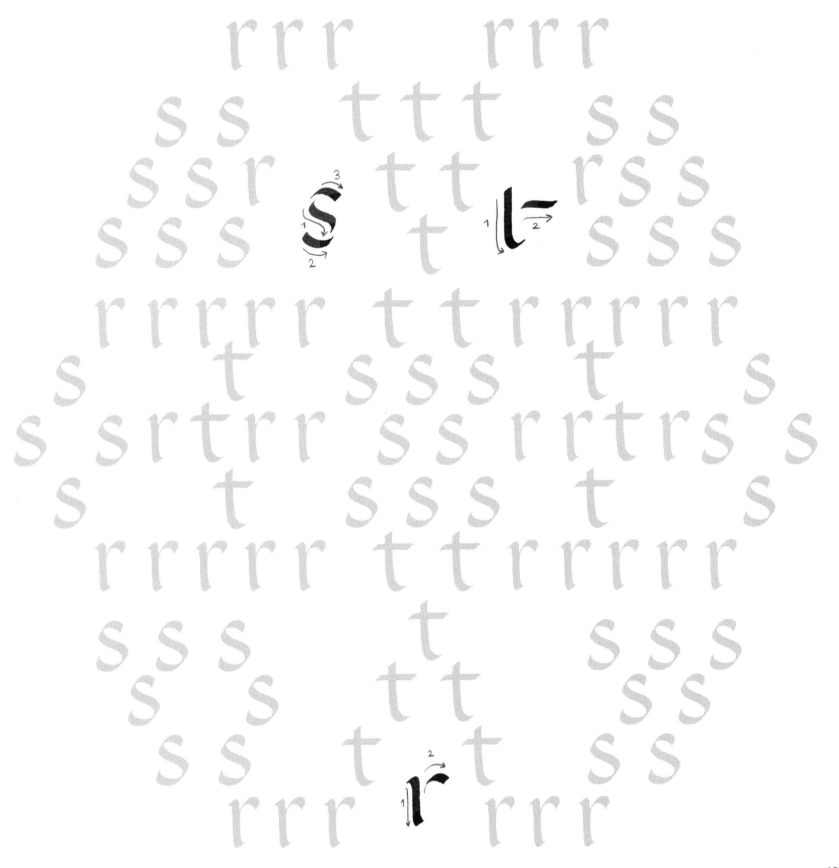

independent

independent

independent

independent

independent

independent

independent

independent

independent

independent

independent

independent

independent

independent